# UNIQUELY CORK

Photographs and Text

by

Niall Foley, L.R.P.S.

D0865540

**THE COLLINS PRESS**

*For Terry*
*Without whose assistance and encouragement
the task would never have been completed.*

Published by The Collins Press, Carey's Lane, The Huguenot Quarter,
Cork

Text and photographs © Niall Foley 1991

First published 1991

This edition published 1998

Printed in Ireland by Colour Books Ltd., Dublin

Typesetting by Kate Duffy

ISBN 1-898256-49-7

'Cork is the loveliest city in the world. Anybody who does not agree with me either was not born there or is prejudiced. The streets are wide, the quays are clean, the bridges are noble. Two wide channels of the river reflect glittering limestone buildings. It is above all, a friendly city, one that you will not easily forget.'

Robert Gibbings
Poet and author.

## BLACKROCK CASTLE

During the reign of James I, Lord Mountjoy, the Viceroy of Ireland, built the first castle on 'The Black Rocks' and there has been some type of castle or fortress on the site since then. The building was originally erected to protect shipping from pirates. It was also used as a type of lighthouse to guide shipping to the city. The light was not the modern type, rather it was a turf fire which was lit on top of the old building. Over the years the building has seen many uses, including that of an admiralty court. One of its main uses was that of a banqueting hall for civic functions. It was during one of these functions that the castle was destroyed by fire. It was rebuilt in 1829 for the sum of £1,000.00. The architects were the brothers Pain from London who also designed the nearby Church of Ireland. The castle is now used as a restaurant and licensed premises.

*Opposite:* The main gates of Blackrock Castle.

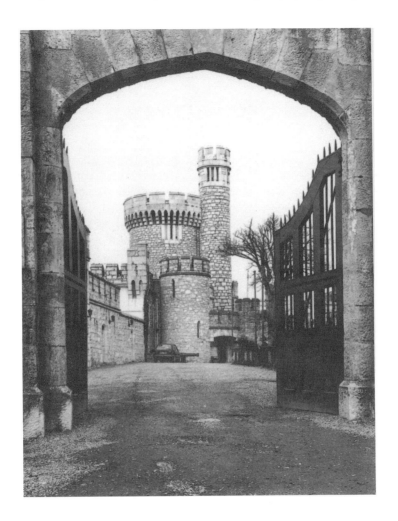

## BLACKROCK

Before the city developed to its present size it was surrounded by a number of small villages. These have now been absorbed into the city and, in the main, it is difficult to recognise the original villages. To some extent Blackrock is the exception. Perhaps its location on the river front has helped it. The community was principally a fishing and market gardening one. When Queen Victoria visited Cork in August of 1849 her procession upriver was interrupted by the fishermen of Blackrock who presented her with a salmon.

*Opposite:* A successor to the salmon fishermen hauling in his boat.

## THE OLD AND THE NEW

If one of the old-time fishermen was to pay a visit to his old port a number of elements would look familiar to him. He would recognise the upturned, wooden fishing boats on the bank but he would surely by nonplussed by the modern container terminal on the Tivoli side of the river. The very fact of there being land in that area would confuse him, as all that was present in his time, was mud flats.

*Opposite:* Wooden fishing boats and high-tech Tivoli docks.

# THE TWENTY-FIVE TO ONE GUN

The city end of the Marina, near Shandon Boat Club, is now a rather quiet area frequented mainly by members of the rowing fraternity. In the earlier part of this century it was a more lively spot. It boasted a bandstand, a ceremonial mound topped with a 140-foot flagpole and a cannon gun which is now set in a concrete plinth. In various parts of the world it was not unusual for a gun to be discharged at midday so that the timepieces of the local inhabitants could be checked. Cork was, however, unique in that its gun was fired at twenty-five minutes to one. This arose out of an agreement made in 1876 between the London Postmaster General and the Cork Harbour Commissioners to allow Greenwich Mean Time to be proclaimed in Cork. This gun, which is a relic of the Crimean War, was set up in its present position and daily a signal was flashed by telegraph from Greenwich to Cork at one. As Cork is five degrees west of Greenwich the gun was fired at twenty-five minutes to one.

The gun was last fired in the 1920s and it would by nice to see the gun and the area restored to its former glory.

*Opposite:* The Twenty-five to One Cannon.

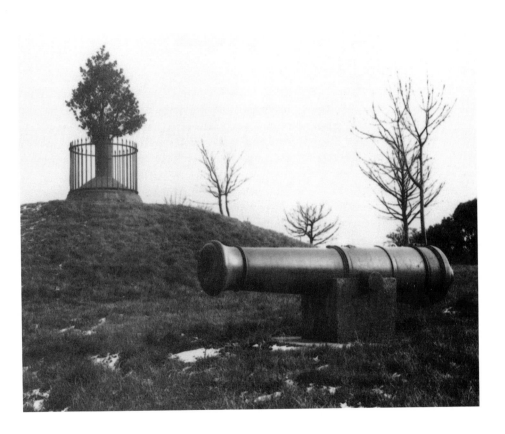

## CITY HALL

This building replaced the old city hall which was burned down in 1920. It is the administrative centre for the city, which by virtue of its ancient charter, is one of the few cities in the country to have a Lord Mayor. He or she and the city councillors are elected by the people to decide on policy matters which are then implemented by the city officials. It is also one of the main cultural centres in the city and its spacious hall is used for events such as the International Choral Festival and symphony orchestra recitals. Attractively located by the river, it can be appreciated from a number of vantage points since it is bounded on three sides by wide roads.

*Opposite:* City Hall viewed from the riverside.

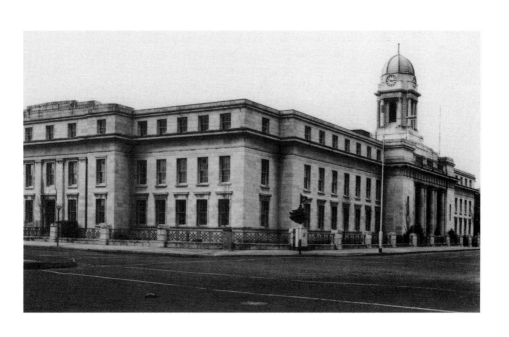

## LOOKING NORTHWEST FROM THE HARBOUR

From a vantage point on top of the grain silos on the southern side of the river there is a panoramic view. In the foreground the two channels of the river converge. This explains why the city can be confusing to visitors who constantly seem to be encountering some branch of the river. In the distance can be seen the wooded slopes above Sundays Well.

*Opposite:* The confluence of the north and south channels of the River Lee.

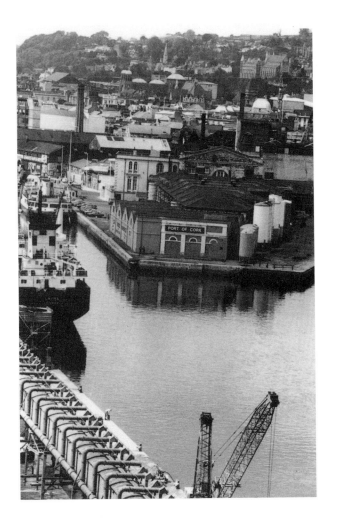

## CORK HARBOUR COMMISSIONERS

Until the two bridges serving the new ring road were built, this attractive building was effectively hidden from view, and many Cork people would not even have known of its existence. The building started life in 1814 as a custom house. Later it was taken over by the Harbour Commissioners. The Cork Coat of Arms replaced the Royal arms which were originally there.

The Harbour Commissioners deal not just with docks and shipping but have jurisdiction over the entire harbour area which stretches for thirteen miles. It is the biggest harbour in the country and is considered to be one of the finest natural harbours in the world.

*Opposite:* Part of the elegant facade.

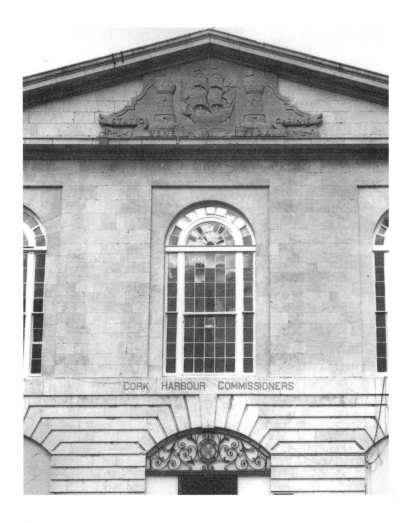

## BONDED WAREHOUSES

The bonded warehouses in the custom-house yard always seem more like a prison than stores, with the barred windows and the circular tower which looks strikingly like a watch tower. The grim appearance is relieved by the use of the typical mixture of local limestone and red sandstone.

*Opposite:* The cobbled yard around the warehouses.

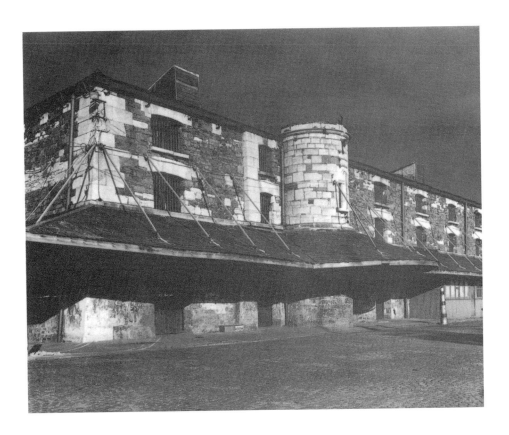

## SOUTH TERRACE

A sense of more elegant times is suggested by this rather attractive Georgian doorway.

*Opposite:* Georgian doorway and steps.

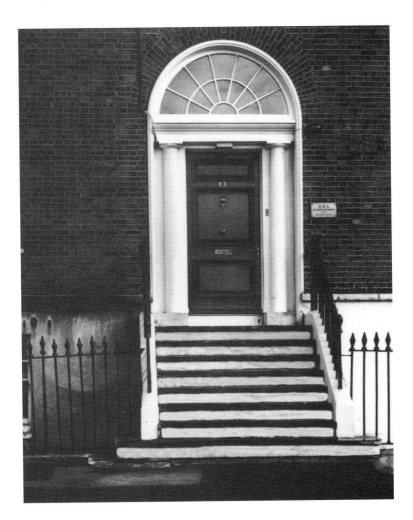

## CHRIST THE KING CHURCH

Churches and public buildings were traditionally stone built and were the major source of employment for local stone masons. There was great consternation when it was announced that the new church in Turners Cross was to be built of concrete. In his book *Stone Mad*, Seamus Murphy R.H.A., tells about his fellow stone masons getting up a delegation to protest to the bishop. Obviously their protestations fell on deaf ears and this most modern and daring of churches was built. It was the design of Barry Byrne, a Chicago architect, who never saw his building erected as the work was supervised by local architects. It is basically a large elliptical building with a vast roof area unsupported by any pillars. It was a most unusual design for its time. The exterior is dominated by a modernistic carving of Christ dividing the main portals.

*Opposite:* The main entrance to Christ the King Church.

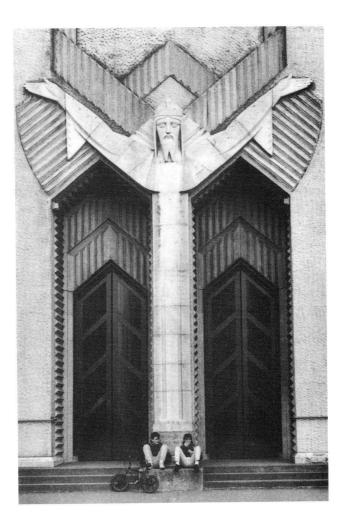

## THE LOUGH

One of the most under-appreciated areas in the city is the Lough. This large, natural lake is a wildfowl sanctuary and during the winter months it provides a home to birds from colder, more northerly climes.

On rare occasions, during very cold winters, the water freezes and for a short period becomes an outdoor skating rink for the brave and daring.

All year round visitors give food to the birds which become tame and feed from people's hands.

A local legend tells how the Lough was formed. The story goes that originally there was only a well on the spot. However, one evening a princess went to the well for water and forgot to seal it after her. During the night the well overflowed swallowing up her father's castle, drowning everybody in it and creating a lake.

*Opposite:* Feeding the swans at the Lough.

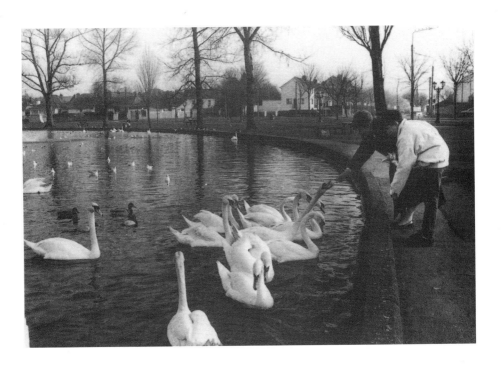

## THE RED ABBEY

The exact age of this building is uncertain but it seems to pre-date 1545. At that stage it was known as Saint Austin's and how it acquired its name as the Red Abbey is not clear. It was an Augustinian friary and not an abbey as such. It is thought that local red sandstone could have been used in the building of the now disappeared church but there is no trace of sandstone in the surviving tower.

The abbey, like so many buildings of its kind, has had a chequered history. During Cromwell's stay in the city his soldiers used it as a stable for their horses. This was his method of showing disrespect for his opponents' religious beliefs. In the latter part of the seventeenth century it was used as a barracks during the Williamite wars. It later became a sugar-refining factory known as the Red Abbey Sugar House. It reached the end of its life on the seventh of December, 1799, when it was destroyed by fire. The remains are cared for by the corporation.

*Opposite:* The surviving tower of the Red Abbey.

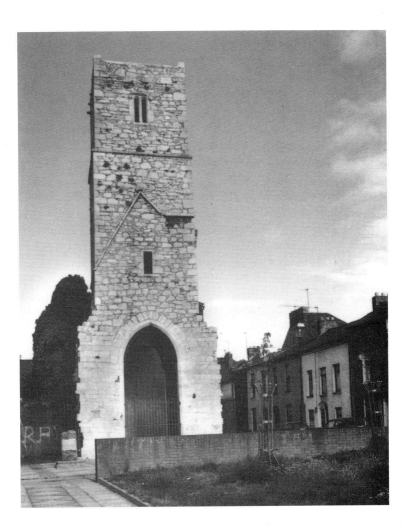

## SAINT FIN BARRE'S CATHEDRAL

In 606 A.D. one of the main monastic schools in Ireland was established on this site. It was set up by St Finbarr (from the Irish fair haired), and to this day the area has been involved in the religious life of the city. There have been numerous churches and cathedrals on this site. Among the treasures of the cathedral is a silver gilt chalice from 1563. Over the centuries the cathedral has seen many turbulent occasions and during the siege of Cork in 1689 the cathedral was badly damaged. In the ambulatory of the present building there is a 24lb cannon ball which was found when the previous smaller cathedral was demolished in 1865.

In 1862 William Burgess, the architect, was appointed to design the present cathedral. His building, which was completed in 1879 at a cost of £40,000, exceeded the initial expected cost by nearly 300 per cent.

The building is mainly of local limestone and red Cork marble is used to line the walls as well as for the fort.

*Opposite:* View of the eastern elevation as seen from the South Gate area of the City.

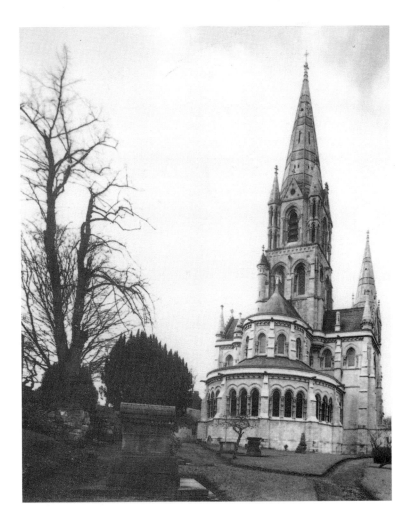

## CATHEDRAL INTERIOR

This view of the interior of St Fin Barre's cathedral shows the attractively painted ceiling. Just inside the altar rails can be seen the Bishop's throne which is forty-six feet high and carved from oak. Twenty of the most prominent bishops of the diocese have their likeness engraved onto the throne. The floor of the sanctuary has a beautiful mosaic covering on the theme of 'fishers of men'.

*Opposite:* Looking up the nave to the main altar.

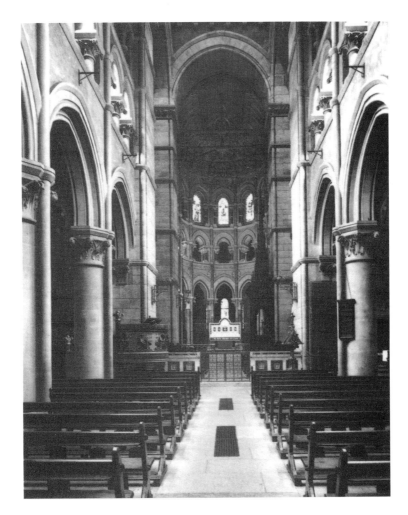

## THE GOLDEN ANGEL

This statue has endeared itself to generations of Corkonians and has attracted a number of legends. One of them is that the end of the world would be signalled by the blowing of the angel's trumpet. Another story is told by Patrick Galvin in his book *Song for a Poor Boy*. He tells how he was reared with the belief that before the end of the world the angel would turn green. Despite the keen ears and observations of generations, the trumpet remains mute and the angel ever golden.

*Opposite:* 'The Goldy Angel'.

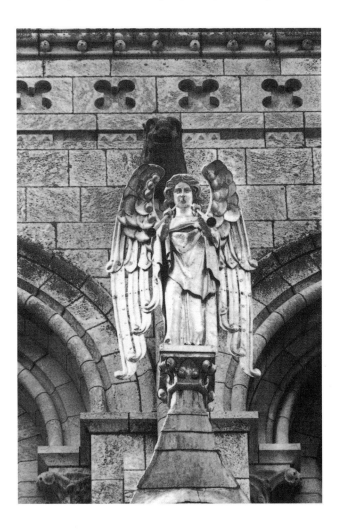

# UNIVERSITY COLLEGE CORK

In 1845 universities were incorporated in Belfast, Cork and Galway and they were known as the Queens Universities in Ireland. They were developed to provide educational opportunities for the children of middle-class people. Previously it was only the sons of aristocrats and the landed gentry who went to university. At one stage Jews, Catholics and Protestant Dissenters were barred from higher education.

The selection of the site for the university was undertaken by the board of works and maybe it is not just a coincidence that they located the collegiate buildings on an outcrop of rock just upstream from where Saint Finbarr formed his monastic school. The board of works supervised the construction of the university. Some eight months after the building was completed and handed over to the college, the Registrar wrote a letter complaining that the Bursar's office still did not have a door.

The student body now numbers thousands and all branches of education from the humanities to the sciences are catered for.

*Opposite:* The north face of the main buildings.

## THE JAIL GATES

Adjacent to the university was one of the city jails. During its lifetime many famous people were held there including some of the Fenian Leaders while they were awaiting sentencing. During more recent times the revolutionary Countess Markievicz had a couple of stays there. In calmer times there was a decrease in the number of prisoners, and in 1958 it was given to the university authorities, who demolished the old jail buildings and developed their science department there. They were obliged to retain the Greek Doric portion which had been modelled after the temple of Bacchus in Athens. To the left of the old prison entrance can be seen a gateway. This was the original entrance to the college. It was felt that it was not proper for staff and students to have to enter by a gate next to a prison and accordingly, the more impressive entrance on the Western Road was developed.

*Opposite:* The Jail portico and the Jail Gates entrance to U.C.C.

## THE STONE CORRIDOR

In the North Wing corridor of the quad in University College Cork are a number of ogham stones which were unearthed around the country. One of the most interesting was discovered in County Cork by a farmer digging up his potatoes. The corridor is popularly known as 'The Stone Corridor'.

*Opposite:* The view along 'The Stone Corridor'.

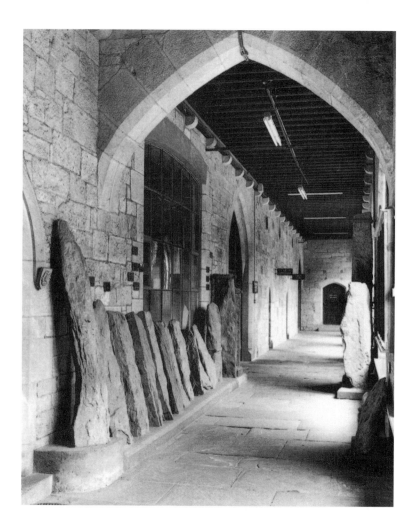

## FITZGERALD'S PARK

This is the oldest and largest of the city parks. During 1902 and 1903 Cork was the venue for an international exhibition. When the exhibition closed the organisers were left with the question of what to do with the site. Eventually it was given to the corporation, developed into a public park and named after Sir Edward Fitzgerald. It is a mixture of formal gardens, open spaces and a large recreation area.

The pond, with its surrounding walk and seats, is a focal point and a meeting place for young and old alike.

*Opposite:* 'Boy and boat' by Joe Higgins.

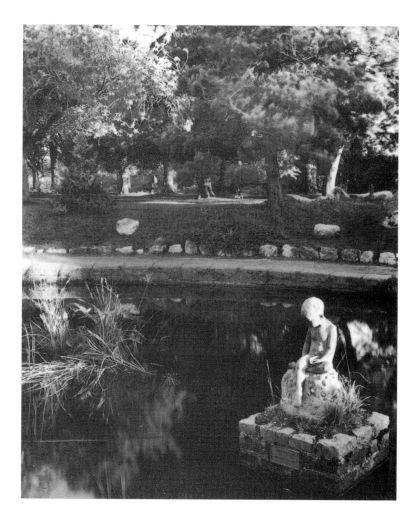

## SCULPTURE

As a result of the activities of the Cork Sculpture Park Committee a section of Fitzgerald's Park has been turned into an open air venue for sculpture. This allows visitors and locals who are relaxing in the park to view and appreciate these works of art.

*Opposite:* 'Dreamtime' by Seamus Murphy R.H.A.

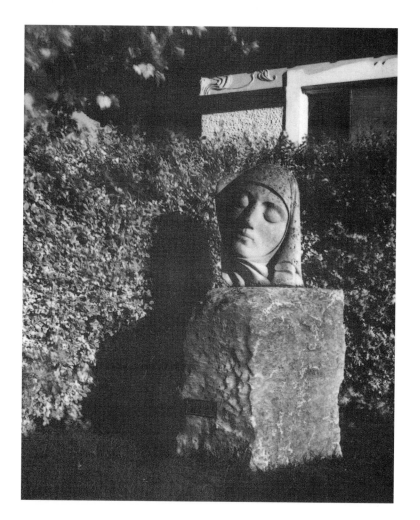

## THE MARDYKE

Adjoining Fitzgerald's Park is the Mardyke. This was laid out as a tree-lined boulevard with a small stream running along one side. The city fathers closed in the stream and in recent times the dreaded Dutch Elm disease necessitated the removal of the old trees. James Joyce visited the area and wrote that:

> *'The leaves of the trees along the Mardyke were astir and whispered in the sunlight'.*

It would be nice to see the old spot restored to its former grandeur. This was a popular residential area and there are still Georgian houses with the wrought iron railings and balconies.

*Opposite:* A Georgian facade on Dyke Parade.

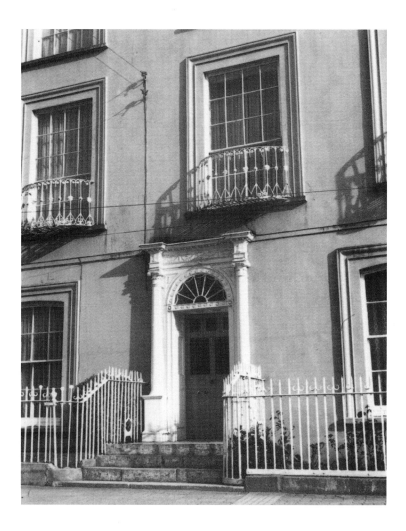

# THE COURTHOUSE

Prior to 1835 Cork had two courthouses, the City and the County. The County Courthouse stood on the site of the present Queens Old Castle shopping mall and some of it was incorporated into its facade. Later the two courthouses were merged into this building, which was opened in 1835, on Washington Street.

Considered the finest neo-classical building in the south of Ireland, it was badly damaged by fire in March 1890. This new building opened in March 1895. Over the portico was a blindfolded statue of Justice. In one hand she held the scales of justice, in the other the sword of justice. The blindfold indicated that justice would be administered impartially, the scales indicated evenness and the sword was a symbol of justice being applied.

During the 1920s the sword and scales were removed by people who felt that justice was not being evenly applied.

*Opposite:* The Courthouse portico on Washington Street.

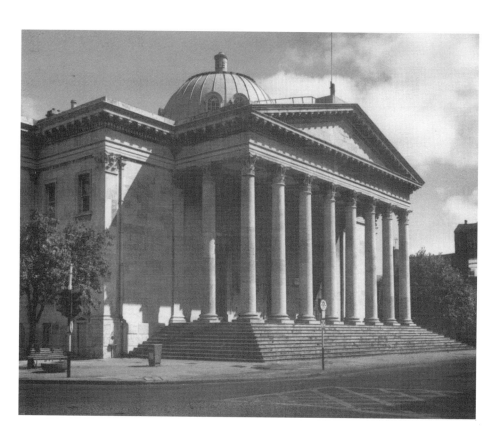

## PUBS

No Irish city would be complete without its interesting pubs. One of the more pleasant public houses in the city is located in Hanover Place. The name over the door says O'Flynns but it is more affectionately known as 'The Morgue'. Whilst pubs tend to be given nicknames by their patrons this is a rather unusual one. It got its name from the fact that a nearby weir in the river tended to trap the bodies of drowning victims as they were being swept down river. In the days before incidents like this were looked after officially and quickly, the tradition grew up of bringing the bodies to this premises while awaiting for the authorities to swing into action.

*Opposite:* The renovated interior.

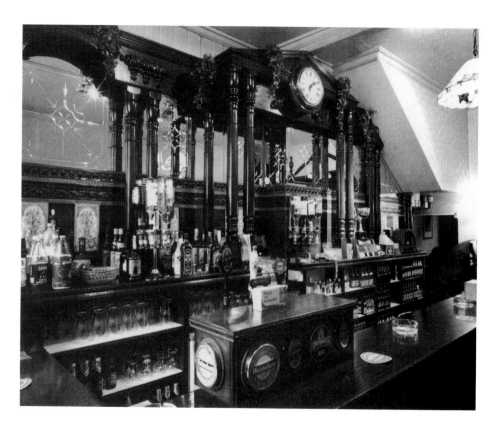

## PORTNEY'S LANE

Looking at Portney's Lane today it is hard to visualise that it was one of the main thoroughfares of the old walled city. In the 1600s it was a fashionable address and, after the Battle of Kinsale, the leader of the unsuccessful Spanish forces was housed here before he was allowed to return to Spain. Perhaps he would have been better off staying in Cork as his master, the King of Spain, was not too pleased with him and he was executed. To this day people still live in this lane and they have painted the wall on the left side white to reflect the maximum amount of light into their homes opposite.

*Opposite:* A sunlit Portney's Lane.

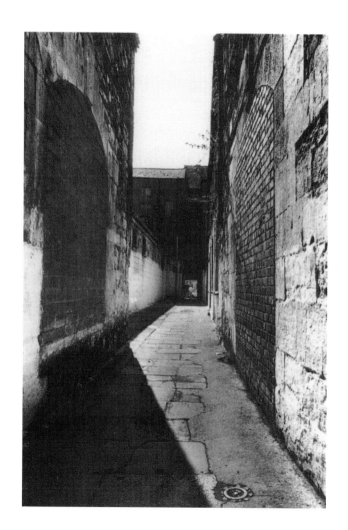

## CLOTHES STALL, CORNMARKET STREET

Despite the proliferation of boutiques and trendy clothes shops in the city, some people prefer to browse at the clothes stalls on the Coal Quay where bargains can still be had.

*Opposite:* Searching for a bargain.

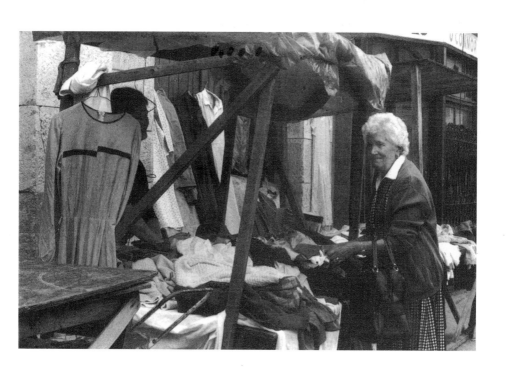

## THE COAL QUAY

Cork would not be Cork without its open-air market called The Coal Quay. To make the matter very much a Cork one, this market does not take place on The Coal Quay at all, but in nearby Cornmarket Street. The idea of the open-air market started with market gardeners from outlying areas bringing in their produce to sell in the wide street. Over the years this evolved into a general market with stalls being passed down from generation to generation usually through the female line. It was formerly a place of great characters. The pubs were permitted to open early in the morning to cater for the traders and it was a lively spot. *Shaw's Tourists Picturesque Guide* in 1881 gave two lively descriptions of the area:

> *'The Coal Quay is a part of the city amusing enough to strangers yet far too unfashionable for the respectable citizens to take much interest in.'*

> *'... their speech was graced with the wildest blossoms of southern rhetoric.'*

*Opposite:* A happy vendor.

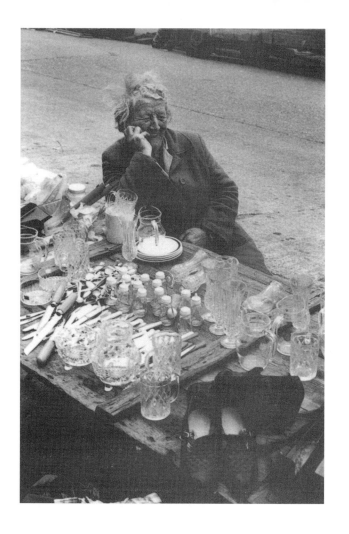

## BICYCLE PARKING

The difficulty of finding secure parking for bicycles is high-lighted by this picture.

*Opposite:* Some people have no respect for authority.

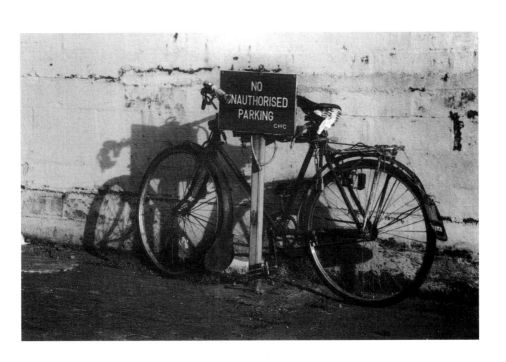

## INNER CITY

One of the traditions of city dwellers was to take advantage of sunny days and to sit and chat on their doorsteps. These ladies are availing of such a sunny evening in Corporation Buildings.

Perhaps the most famous tenant of these flats was Katty Barry who ran a crubeen shop and sheebeen in the area. Many stories are told about this lady. One is that, when on one occasion she was being prosecuted for after-hours drinking, the stern-faced judge demanded an explanation of her behaviour. She replied that she did not have to explain anything to him seeing as how he had spent so much time on her premises when he was a law student.

*Opposite:* The pleasures of age.

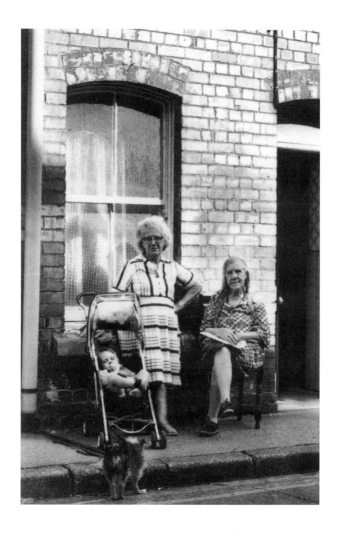

## KEEPING A WEATHER EYE

This little fellow immediately brings to mind the old song *'How much is the doggie in the window?'* For many years this dog, whose name was Judy, was the faithful friend of the late Mrs Kitty Barrett of Corporation Buildings. She lived in a first floor apartment and her dog, as is common with so many of its type, loved to stand at the open window on a sunny day and watch what was going on outside.

*Opposite:* Judy enjoying the view.

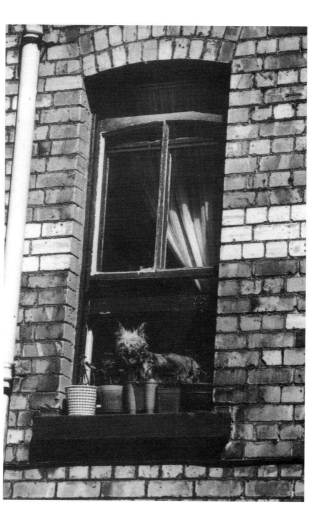

## GRAND PARADE

The Irish for this street is *Sráid an Capaill Bhuidhe*. This name came from an equestrian statue which stood where the National Monument now stands. The statue was erected to honour a British Monarch but it had a rather unfortunate history. As the monarchs changed, different heads were put on the statue. After some years the horse started to lean over and a prop had to be put under it. Subsequently the statue itself started to topple and it also had to be propped. Eventually, horse and rider were removed.

The National Monument was erected by the Cork Young Ireland Society to honour various patriotic uprisings. The large building is the regional office of the Industrial Credit Corporation. Previously it had served as a gentlemen's club and was later owned by a religious organisation.

The three slate-clad, bow-fronted houses date from the eighteenth century.

*Opposite:* The junction of the Grand Parade with the South Mall.

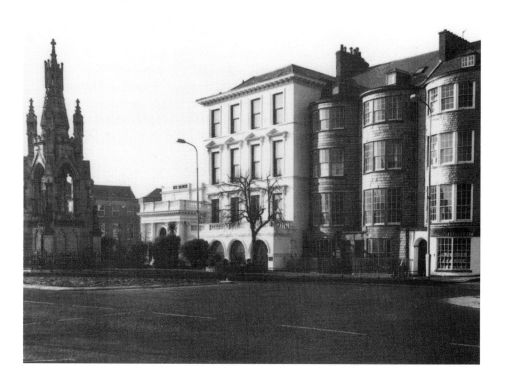

## BERWICK FOUNTAIN AND BISHOP LUCEY PARK GATES

The Berwick Fountain was the first publicly-erected tribute to Father Matthew. Erected in 1860 it was paid for by Judge Berwick. The inscription around it says that it was in thanks for the kindness shown to him by all classes of people in the city. Unfortunately the fountain was not universally appreciated. A local ballad of the time commented:

> *'But Mavrone, all the labour and money was lost,*
> *for it scatters the water which comes from its top,*
> *and 'twill wash down your shutters, thus saving a mop.*
> *While it works, try to pass it with shining silk hat,*
> *And 'tis clear of the fountain you'll keep after that.'*

Behind the fountain are the large gates forming the entrance to Bishop Lucey Park. These were originally the gates to the haymarket in Anglesea Street. After this market closed down it became part of the yards owned by the corporation. When this area was being developed the gates were taken down and re-erected here.

*Opposite:* The Fountain and Gates.

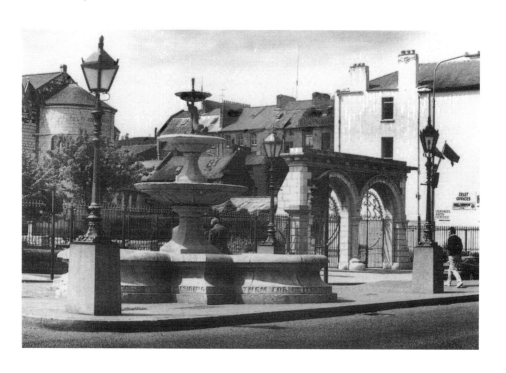

## PARK SCULPTURE

On a pleasant afternoon Bishop Lucey Park attracts many visitors who can enjoy the sunshine in tranquil surroundings. The centrepiece of the park is a large fountain by the sculptor, John Behan. It takes the unusual form of eight swans in flight with the water cascading over their wings. In the foreground is an equally famous sculpture by Cork's best known sculptor of this century, Seamus Murphy, R.H.A. Its title is 'The Onion Seller'.

*Opposite:* A view of the park.

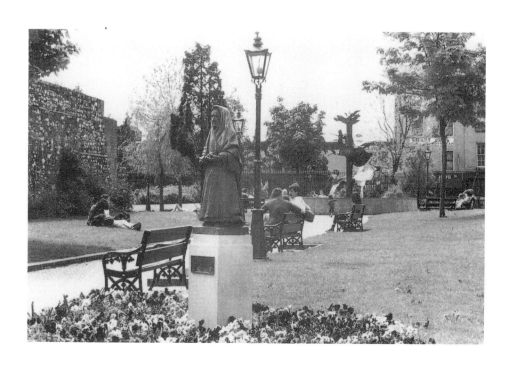

## MARKET LANE

The narrow passageway known as Market Lane joins Patrick Street with the market. This lane, which is partly arched over, contained two of Cork's oldest and most famous hostelries; the Vineyard and the Oyster Tavern. Happily, the Vineyard is still a thriving establishment. Sadly, the Oyster is no longer with us, but its fame was so widespread that after the last war it was not unusual for gourmets from ration-controlled England to fly into Cork for a steak at the Oyster Tavern.

*Opposite:* Looking down Market Lane from Patrick Street.

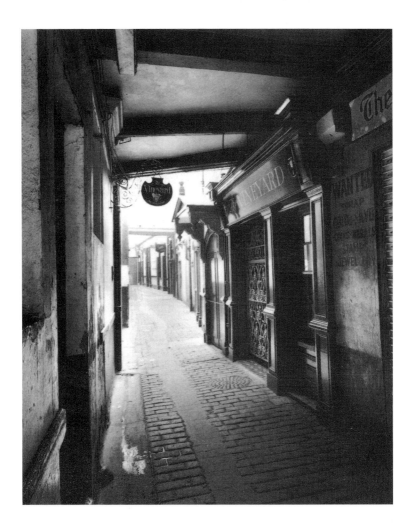

## S.S. PETER AND PAUL'S

This lovely Gothic-style church was designed by the famous architect Pugin. It is built out of local red sandstone and white limestone was used for ornamentation. The foundation stone was laid in 1859. This section of the city was bordering on an area known as 'The Marsh', which was a rabbit warren of lanes teeming with hovels and underfed, poorly clad people.

Yet the funds were raised for this magnificent building and it was a matter of great pride to its parishioners. It is a pity that it is approached by a narrow street since its beauty would be better appreciated in an open area.

The man charged with supervising the construction was the Venerable Archdeacon J.J. Murphy. His must have been a rather late vocation, his career prior to ordination having ranged from participating in the Battle of Trafalgar with the Royal Navy to being a fur trader in Canada and being made an Indian Chief. He returned to Ireland, took up Holy Orders and during the famine period worked in West Cork, one of the most affected areas. He was subsequently appointed Archdeacon of his native city and this building stands as a tribute and monument to a most unusual gentleman.

*Opposite:* S.S. Peter and Paul's Church.

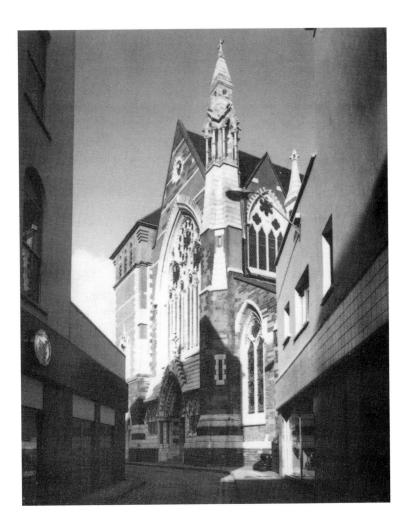

## SELLING 'DE PAPER '

The Echo Boys are one of the institutions of the city. Traditionally they have dodged in and out of the traffic and pedestrians exhorting people to buy 'de paper'. There was such a number of them that they had their own club and went on holidays to the seaside together.

Some of them have now gone a bit upmarket and have their own stand.

*Opposite:* A sedentary Echo Boy.

## FATHER THEOBALD MATTHEW

In the mythology of Cork this gentleman must surely rank very high. Born in Thomastown County Tipperary in October 1790, he studied for the priesthood at Maynooth. He had to leave rather hurriedly as a result of holding an unauthorised party in his room. He was subsequently ordained as a Capuchin priest in 1813. When he came to Cork he lived at number 10 Cove Street.

He laboured generally for the needy and established a school for underprivileged girls. During the famine years he worked to help the starving. In 1822 he was elected provincial of the order and held this position for 29 years until forced by illness to retire.

In April 1838 Father Matthew became involved with the temperance movement and was elected president of the Cork Total Abstinence Society. He preached the temperance message not only in Ireland but in Europe and America.

After his death in 1856 a movement was formed to erect a statue in his honour. This was unveiled in 1882 and it is reported that the crowd exceeded 100,000 people. Excursion trains ran from Limerick and other places and steamers came from surrounding ports.

*Opposite:* The statue in Patrick Street.

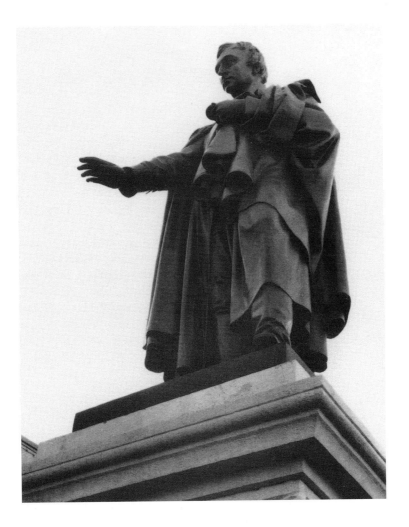

## MANGAN'S CLOCK

Before the development of the new shopping mall a row of shops fronted onto this part of Patrick Street. The most famous of them was Mangan's Jewellers which opened its doors for business in 1817. As well as being a jewellery shop they made clocks and installed them all over the country. Their most famous clock was installed in Shandon.

On the street outside the shop was erected a large pedestal clock which was a favourite meeting place for young lovers. The mechanism for this clock was powered by a shaft running through a basement under the street. This shaft was driven by a large weight which hung from the second floor of the shop. When the shopping mall was built the town planners insisted that the old freestanding clock be retained on the pavement.

*Opposite:* Mangan's Clock outside Merchants Quay shopping centre.

## PATRICK'S BRIDGE

This elegant, triple-arched bridge spans the northern channel of the River Lee at the end of Patrick Street. It is one of the bridges joining the city centre to the north side.

In years past it was common to see shoals of mullet around the bridge but due to pollution they have been missing for some time. The problem is being tackled and fish life is starting to return but at one stage this situation was so bad that a section of a local ballad, referring to the nearby statue of Father Matthew, went:

> *'The smell from the River Lee is wicked,*
> *How does Father Matthew stick it'.*

Camden Place on the far side of the river is an attractive row of red-bricked Georgian houses with a rather distinctive bank building at the corner. In the distance can be seen the spire of Shandon which dominates the northern skyline.

*Opposite:* Patrick's Bridge and Camden Place.

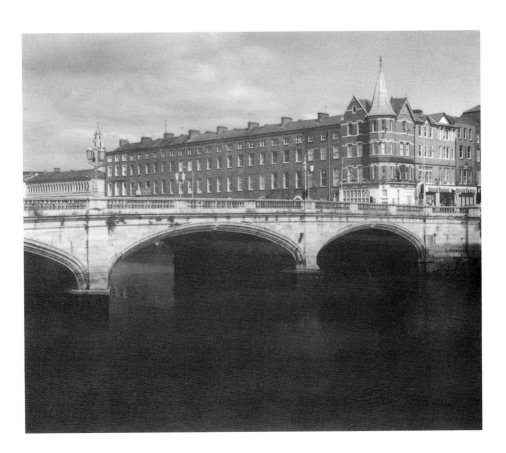

## PATRICK'S HILL

This is the steepest hill in the city. With the popularity of cycle racing as a television spectator sport most people will be familiar with it as the gruelling hill cyclists usually have to climb when they arrive in the city.

Long before cycling became a popular sport this hill achieved a local fame of its own for cycling. Prior to the supermarket era, every decent-sized shop in town had its messenger boy with his heavy-framed delivery bike. For the daring among the messenger-boy fraternity this hill provided a special challenge. They delighted in riding downhill at speed and the guard on traffic duty at Patrick's Bridge would be left with no option but to hurriedly block all oncoming traffic and allow the hurtling messenger boy through. The idea was to see who could free-wheel farthest down Patrick Street and not get caught by the guards. Now that the guards have been replaced by unthinking traffic lights a cyclist would have to be very foolhardy before he could ever think of such a venture.

*Opposite:* Patrick's Hill as seen from Bridge Street.

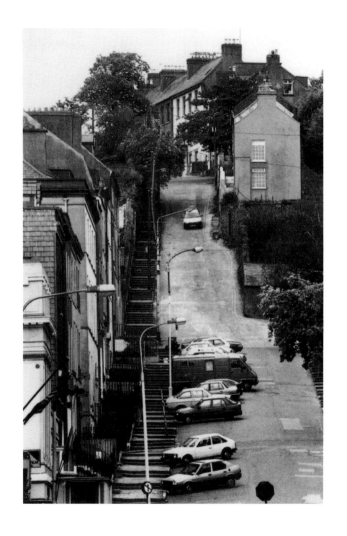

## EMMET PLACE

In the not so distant past the centre of the city must have looked something like Venice. Many of the streets we take for granted today were waterways and what we know as Emmet Place was a U-shaped quay known as Kings Dock. The building which is now the Municipal Art Gallery started life as a custom house to serve the vessels that docked here from all over the world.

The fountain, which the corporation has erected with the distances to various European capitals marked on it, is a reminder of the vessels which called here from all over the world.

*Opposite:* The Emmet Place fountain.

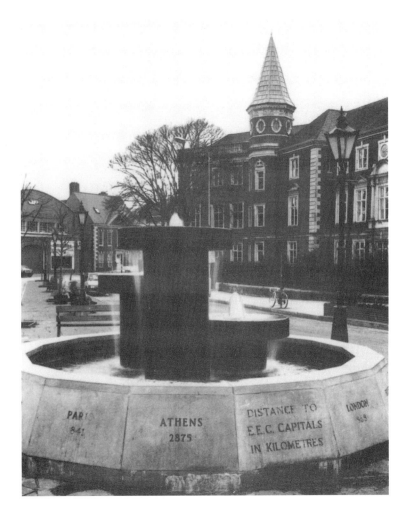

## THE ENGLISH MARKET

The English Market is an indoor market which at its peak had 113 different stalls. They sold items such as fish, meat, poultry, vegetables and fruit. In recent years it was extensively renovated following a fire. It is good to see that the old fountain was retained. People assume that this was built just for its decorative affect but it was also for functional reasons. When the market was built in 1610 this was the only source of fresh running water and stallholders requiring water had to fetch it in buckets from the fountain.

A feature of the market which has disappeared are the 'Beadles'. For over a hundred years they were the market's own police force and the civic authorities were only allowed in by invitation. The force was disbanded in 1925.

*Opposite:* The stalls with their brightly coloured awnings lend a continental air.

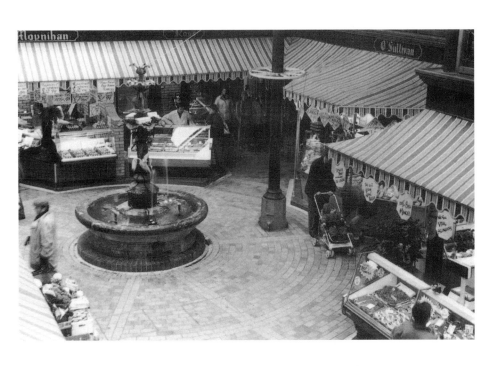

## TRIPE AND DRISHEEN

A favourite Cork delicacy sold in the English Market is tripe and drisheen. Tripe is the lining of the animals' stomach and drisheen is a sausage-like pudding made principally from the blood of animals. Sunday morning was usually the time this particular treat was enjoyed. In recent years this dish has not found favour with the younger generation and is becoming rarer.

Butter was one of the staple goods sold in the market. It was none of your modern low-calorie, fancily packaged stuff. The butter came in boxes from outlying dairies and was cut and shaped as required by the housewife. All this was before the E.C. regulations or refrigeration and nobody seemed to be any the worse for it.

*Opposite:* A traditional display of meat products.

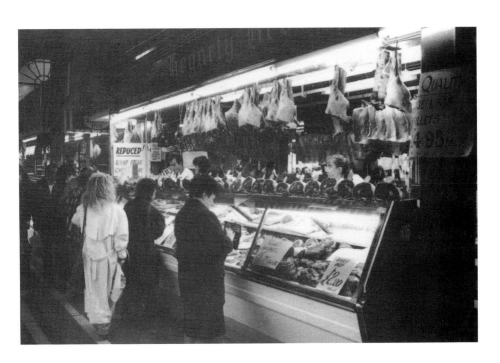

## NUMBER 66, SOUTH MALL

This beautiful limestone building was opened in 1916 as the headquarters of the Munster and Leinster Bank. Later it became part of the Allied Irish Banks Group.

In his book *Stone Mad*, the sculptor, Seamus Murphy R.H.A., mentions that the local stone masons were very upset by finished work being imported from England. This was the cause of a delegation being sent to the bank to protest. Local feelings were assuaged by the rest of the work being done by local men. One interesting by-product of the construction of the building is the very good acoustics and visiting choirs regularly give recitals here.

*Opposite:* A most imposing facade.

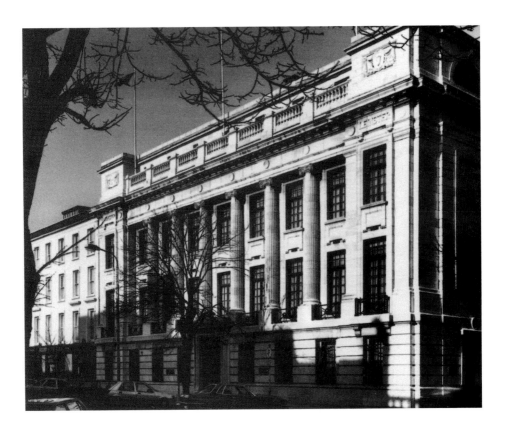

## THE BANKS

These two fine buildings grace the intersection of the South Mall, Lapps Quay and Parnell Place. On the left was formerly the old Provincial Bank, before it became part of the Allied Irish Banks Group. This was the first joint stock bank in these islands and it has been described as having an extravagance of sculptural enrichment. It is highly ornamented and over the windows are carved the coats of arms of many of the centres of commerce in Ireland. At roof level the parapet walls contain carvings of some of the commercial activities in the city.

The other building is the head office of the Cork and Limerick Savings Bank. Presumably it was merely a coincidence that the act setting up the Trustee Savings Banks in Ireland received the Royal Assent on the same day as the act setting up the institutions for the lunatic poor of the country! These banks were set up to encourage thrift and temperance among the smaller savers at a time when many local small banks were failing.

Under its present management the bank has expanded considerably and now has branches in many of the larger towns. This expansion was foreseen at the founding meeting when one of the promoters said that they should be planning to have more than one branch.

*Opposite:* A view of the banks from the quays.

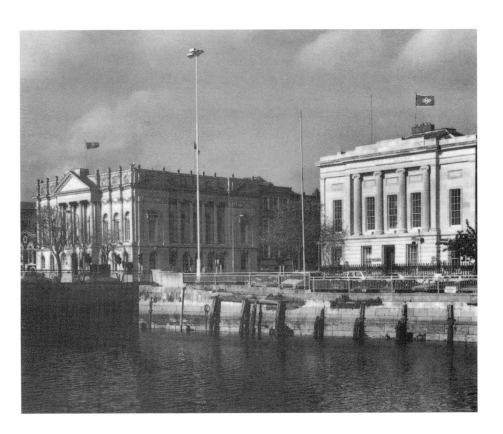

## FATHER MATTHEW QUAY

This Capuchin church and monastery will always be associated in the hearts of Cork people with Father Matthew of temperance fame. It is an ornately designed church whose spire seems out of proportion with the rest of the building. The spire was intended to be taller but finances did not allow it.

*Opposite:* Holy Trinity Church and Friary.

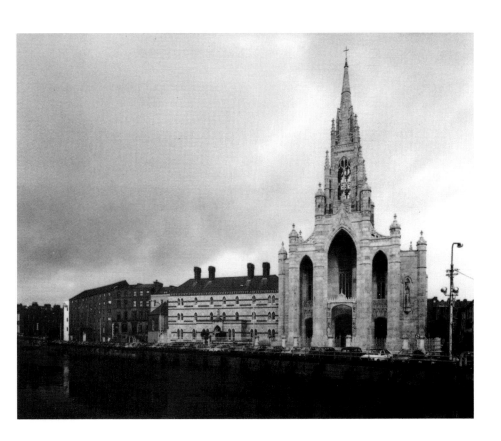

## MORRISON'S ISLAND

The very name of this area brings us back to the fact that the city centre was a group of islands and marshy areas surrounded by arms of the river. This section is bounded by the southern channel of the river and in the evening light the buildings seem to  glow and cast attractive reflections on the water.

*Opposite:* Moore's Hotel, a well-known feature of Morrison's Island.

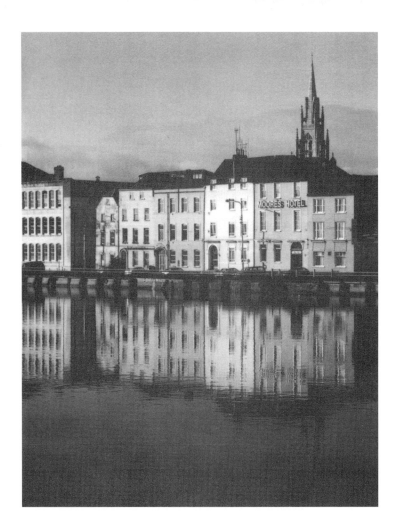

## SAINT LUKE'S

Saint Luke's Cross is unique in having the last surviving toll booth in the city. These booths were set up by the corporation when they were given a charter which allowed them to collect tolls on goods entering the city by land. The toll was one penny per head of cattle and a halfpenny on pigs and sheep. These amounts were in pre-decimal currency. The right was extant up to 1967 when it was formally abandoned. To the right of the toll booth is an old horse trough. These water troughs were a regular feature of the city in the days of delivery horses and a few of them still survive.

In the background is the lovely Romanesque church of Saint Luke's. As is so common around the city it is a mixture of red sandstone and white limestone. This mixture was so popular that it was dubbed the Streaky Bacon effect.

*Opposite:* The toll booth and trough at Saint Luke's Cross.

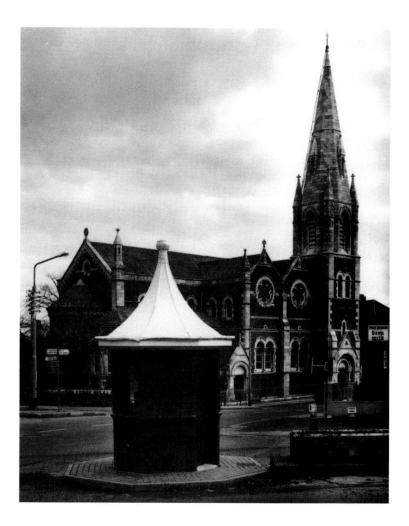

## LOOKING NORTH FROM KENT STATION

A feature of Cork city is that it is built in a valley, the commercial centre is on the valley floor and the residential areas are on the surrounding hills. This is most dramatically seen on the northern side of the river. Hidden under the sign for Paddy Whiskey is the railway track for Dublin. This passes under the hills and emerges on the far side of Blackpool.

*Opposite:* Tiered terraces overlooking Lower Glanmire Road.

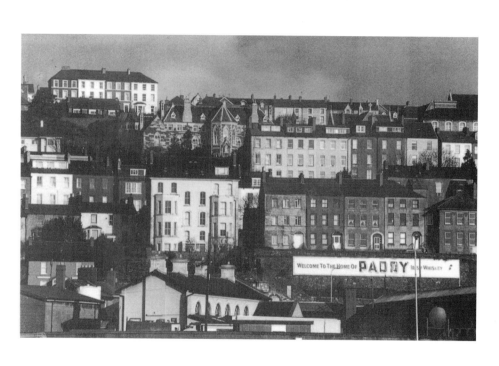

## URBAN RENEWAL

When the slums in the city centre were being cleared extensive developments occurred on the north side of the river. Gurranabraher church on the skyline is five hundred feet above the river level. Because of the fact that somebody looking up to the heights from the city centre could only see a collection of roofs, the area got the name of 'The Red City'.

*Opposite:* Modern housing developments looking north from the Lavitts Quay car park.

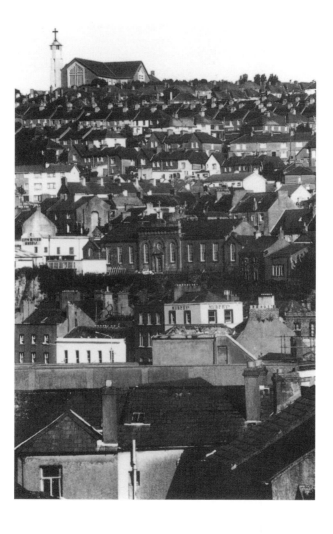

## A TRINITY OF CHURCHES

Looking north across the river from the multi-storey car park on Lavitts Quay the upper sections of these three churches come together in a rather interesting way. In the foreground is the Dominican church of Saint Mary's on Popes Quay. To the left and behind it is the familiar and much loved pepperpot shape of Shandon. In the distance the tower of the Catholic cathedral rises over the roof tops.

*Opposite:* Saint Mary's, Shandon and the Cathedral.

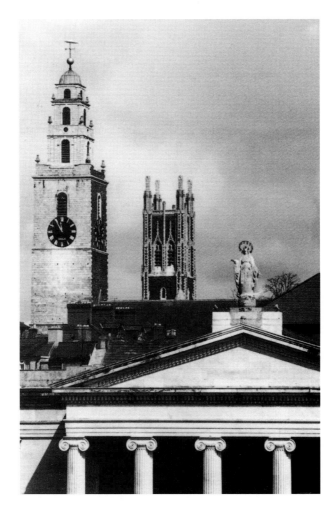

## SAINT MARY'S CATHEDRAL

In terms of ecclesiastical architecture in the city, the Catholic cathedral or the North Chapel, as it is more commonly known, is rather overshadowed by the more imposing Saint Fin Barre's and the nearby Shandon.

This cathedral serves a very large area of the north side of the city. It sits on a level site at the top of Shandon Street, a spot where the rising ground seems to pause briefly before tackling the heights of Gurranabraher.

The cathedral is interestingly juxtaposed with the rather more temporal presence of a bookmaker's shop which presumably allows people to hedge their bets.

*Opposite:* The North Chapel.

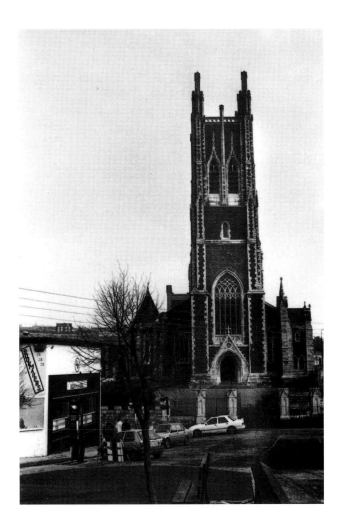

## SHANDON AND THE BUTTER EXCHANGE

The name Shandon comes from *Sean Dún*, the Irish for an old fort. The church is over two hundred years old. It has an unusually designed weather-vane in the form of a golden salmon. Two different types of stone were used in the construction of the tower, the reason for this has given rise to various stories. One is that two different contractors were engaged to build the tower and that each of them had a different quarry. Therefore, two faces are of red sandstone and two of limestone. Another story is that the more genteel limestone faced in towards the city, whilst the rougher sandstone faced out into what was at that stage the country.

Each face of the tower has a clock on it. This was the largest four-faced tower clock in Europe until Big Ben in London was developed. For some reason all the faces used to show slightly different times and this earned it the nickname of 'the four-faced liar'.

The building in the foreground is the remains of the old Butter Exchange. It began in 1796 as a butter market and the quality of its produce became so famous that it was at one stage the hub of the butter world. Butter was shipped to places as far away as India. The Shandon Craft Centreand the Cork Butter Museum are now located in the Butter Exchange building.

*Opposite:* The Butter Exchange and Shandon Steeple.

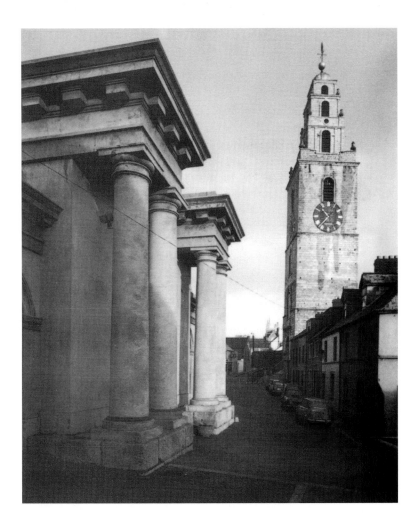

## GOING DOWNTOWN

This young girl seems to be in a hurry to get to town as she skips ahead of the others. The narrow street is typical of many on the northside where the steep roadway had to be cut with grooves to allow the delivery horses to get a grip with their iron horseshoes and to prevent them from slipping.

*Opposite:* Traversing Easons Hill.

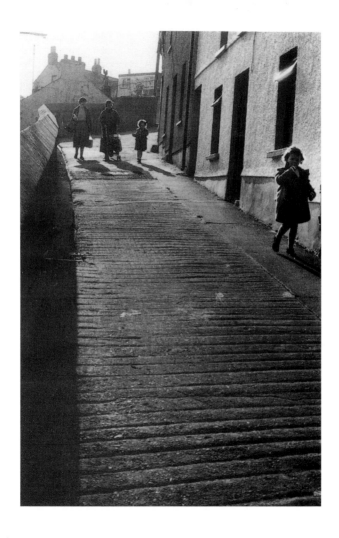

## BARRY'S PLACE

James Barry, a prodigious artist, was born and reared in this area. At a young age he was made a member of the Royal Academy and appointed their professor of painting. He was regarded as having one of the greatest artistic intellects of his age, but because of an irascible temper he was eventually expelled from the Royal Academy. He is one of the very few Corkmen to be buried in Saint Paul's Cathedral in London.

His sister was also an interesting character. Disguised as a man she qualified as a medical doctor and served with distinction in the British Navy, without her true sex ever being discovered. It was only after her death that her secret was uncovered.

*Opposite:* Plaque erected at Barry's Place, Blackpool.

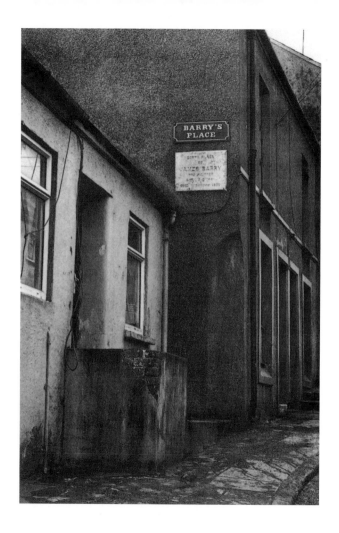